CONTENTS

ACTING
FOR NON-MAJORS

Gregory Horton

North Carolina Agricultural and
Technical State University

Broadway

Kendall Hunt
publishing company

Kendall Hunt
publishing company

www.kendallhunt.com
Send all inquiries to:
4050 Westmark Drive
Dubuque, IA 52004-1840

ISBN 978-1-4652-7066-5

Printed in the United States of America

INTRODUCTION

This text is to be used as a guiding force for the Acting for Non-Majors course. It is derived from numerous class participants prior to your taking the course down through the years. I am happy to say that most of the exercises in this text will help you understand the beginning stages of acting. The text is meant to teach and further your knowledge about basic acting and speaking skills. Please take in as much as you can; prepare yourself to become sensitive to what it is like to be an actor. Methods that are taught in this text should provide a basic foundation and entry-level fundamentals. It is my hope that you will take from this course strong presentational abilities which can assist you in standing in front of an audience and encourage your self-awareness. As outlined in the book, *Acting Is Believing,* one cannot be a good actor if you do not develop a strong skin and be willing to accept criticism. It is my hope that you try and understand what works personally for you and take what applies to you from this workbook. *Acting Is Believing,* as stated before according to McGaw, Stilson, and Clark, "what a simple definition, yet how complex the concept. Nevertheless, there is a challenge, a goal for your study and practice." I think they believe that if you trust in your intent and your instinctive intuition, one can convince an audience to take the ride with you. In any account, true feelings and real circumstances will prompt success and this is good for a beginning acting student. Take this workbook for what it is — a working journal of ideas that I have put together for you from experimental teaching through the years — I hope it will preface a launching that you will see quickly. Be daring, hopeful, intuitive, and willing to go where others will not!

COURSE SYLLABUS

Course Information

Course Number/Section **THEA 110**
Course Title Acting for Non-Majors

Term Fall 2015
Days and Times Monday-Wednesday, 9:00-10:15, Section 001
 Monday-Wednesday, 3:00-4:15, Section 004

Professor Contact Information

Office Phone 336-334-7852 /285-3500
Other Phone 336-547-8446 Home
Email Address gjhorton@ncat.edu
Office Location GCB A302G
Office Hours M-W 1:00-3:00 / T-TH 1:00-3:00 and or by appointment

Other Information

N/A

Course Pre-requisites, Co-requisites, and/or Other Restrictions

There are no course pre- or co-requisites; the course is open to other majors as an elective.

Course Description

This course is set up to teach basic acting skills with the objective to develop personal confidence and self-awareness. It is a first course in performance to lay down guidelines and set up discipline ideals of how to perform in a theatrical setting. During this process, it is our hope to further enhance the natural talents of each student. It will be necessary for each participant to be familiar with theatre terms as well as being sensitive to your presence as an actor in any given environment. We will work toward honesty and a sense of being the characters assigned to you. Please allow flexibility in your everyday movement and actions. Be willing to propel your vision and attitude of who you are personally. Leave your cares and worries at the door, allow yourself to be an open vessel to receive any learning challenges.

Student Learning Objectives/Outcomes (Students will):

1. All class participants are asked to wear comfortable and loose-fitting clothing.

 Outcome: Student will be uninhibited in their movement in class clothing as to allow for free movement and floor exercises. Example: sweatpants, a T-shirt or sweat-top, and comfortable shoes.

2. Students are asked to purchase a notebook for class notes and to record journal entries.

 Outcome: Asking the students to write in their journals allows them to record daily thoughts and feelings that can be used in future class participation exercises, and taking proper notes will keep them abreast of important lectures.

3. Students are asked to record personal thoughts at least three times a week in the journal, if not more. Please date each entry in journals. Journals will be taken up by instructor every two weeks. Please take the journals seriously — they are your outlet for expressions and thoughts you do not wish to share with classmates. The entries are strictly confidential. (See handout on class journal.)

 Outcome: This confidential entry allows the student to express their inner thoughts and feelings that may or may not be shared with anyone else but is a mechanism for self assessment and self inventory.

4. Students will be asked to memorize monologues, three personal and one class monologue and a final scene with a partner.

 Outcome: This is a way for students to showcase their skills in acting as taught through classroom exercises and class participation.

5. There will be one mid-term exam, based on class notes and discussions, and terms and chapters from the class text.

 Outcome: This is a way through written form for the instructor to see if the student is comprehending information rendered during the class lectures and demonstrations.

6. The final exam is a performance exam on the university-assigned date.

 Outcome: Making the student aware that the final exam is in practicum form instead of written form.

7. Students will be expected to participate in all class exercises unless there are medical or physical handicaps that do not permit one to do so.

 Outcome: The student must be aware that participation in this course is a high priority and the student must participate to receive a passing grade in the course, unless there are physical limitations documented through a letter from the office of Student Disabilities.

8. There will be some partner exercises in class. It is imperative for all students to be in class at each meeting, on time and ready to work.

 Outcome: Working with a partner in class is a special part of the course that allows the students involved to get to work with another actor, other than themselves, encouraging partner work.

9. To learn all you can about acting.

 Outcome: It is the intent of this course to teach as much about the acting discipline as possible, to make the participants knowledgeable about the acting profession.

10. To be open and not be afraid to try anything.

 Outcome: If the student allows themselves to become seriously immersed in the course and come as an open vessel, taking in all the course has to offer, what they take away will be much more fulfilling and allow them to be able to use what they have learned in real-life experiences.

11. You are required to see both Richard B. Harrison Players performances this semester and write a critique. (**Note: Performances are assigned in the city for the summer, may include movies as well.**)

Student Learning Objectives/Outcomes (Graduate)
N/A

Required Textbooks and Materials (None required. There is no official course text.)
Acting One, by Robert Cohen /4th Edition (Reference Text)

Other Reference Text Materials:
Respect for Acting, by Uta Hagen
Acting Is Believing, by McGaw, Stilson, and Clark

Assignments and Academic Calendar

A notebook for recording class notes and journal entries.

Assignments and Academic Calendar

Topics, reading assignments, due dates, exam dates (**Optional**: Withdrawal dates, holidays, etc.)

Class Schedule

(Note: Weeks are condensed during summer session. Summer Schedule: Weeks 1-3 - Week 1, Weeks 4-6 - Week 2, Weeks 7-10 - Week 3, Weeks 11-13 - Week 4, Weeks 14-16 - Week 5)

Week 1: Introductions, Name game, relaxation/trust exercises, "This Is a What" (memory repetition game), stage directions and terms, environmental movement pieces
explained for next week's class assignment. Warming up. Explain beats and scoring.

Homework: To Sit in Solemn Silence (memorize) Work Environmental Scenes.

Week 2: Acting definitions and lingo. See *Acting Is Believing*, pp. 15-25, introduction to state of mind, emotions, "I want" improvise monologue memorized with partner. Create class creed. Stage and set up class creed.

Homework: Work on memorized monologue in gibberish, reciting at 200% or dramatic, mime, make into song in any style. Choose a monologue.

Week 3: Finish environmental movement pieces. Do homework. Do "To Sit" with emotional recall and subtext. See handout on Uta Hagen's *Respect for Acting* "the three entrances" energy work, visualization, what is character analysis (handout).

Homework: Start to memorize monologue: secure two copies one to read one and one to mark Scoring and beats.

Week 4: Beats and Scoring on Monologues due. Work monologues in class, critique Rework. Work with partners on each others' monologue, give feed back. Block monologues.

Homework: Memorize monologue, rehearse environmental scene with partner.

Week 5: Environmental scene performed and critiqued. All monologues blocked and memorized. Run all monologues. Discuss inner dialogue and subtext. Open critique of everyone's work. Work on adjustments.

Homework: Write and prepare oral reports on famous acting teacher or actor.

Week 6: Tape monologues. Critique first taping, redo with adjustments. Turn in written reports of famous actor or acting teacher, give oral report and make copies for classmates.

Week 7: Guest artist will join us for class. (TBA) Acting with music. Students bring favorite music to start work on scene with music being the basis. Talk about guest artist visit.

Homework: Study for mid-term/choose second monologue.

Week 8: Take mid-term exam. Present pieces with music. Reports for on-campus first production due.

Week 9: Trip off campus to see show or visit professional theater in Greensboro (TBA). Find a scene with two people that requires lots of action; work with partner for the next week.

Week 10: In depth work on two-people scenes, tape the work on those scenes.

Week 11: Report on an acting technique to share with class.

Week 12: Serious work on second monologue for final.

Week 13: Serious work on partner scenes.

Week 14: Clean up and blocking finalizations on scenes.

Week 15: Continue clean up and work on monologues and partner scenes.

Week 16: Monologues/duo scenes due. You Did It!

Play Viewing: Students are asked to see the two plays rendered by the Theatre Department during the semester in which they take this course.

Grading Policy

GRADING:		
Class Journal		50
Critiques (2 @ 50)		100
Monologues 1, 2, 3	(3 @50)	150
Duologue/Final		100
Personalities (2 @ 50)		100
Total		500

Plus/Minus Grading 10-Point Scale

Grade	Quality Points	10-Point Scale
A	4.0	500-494
A-	3.7	493-487
B+	3.3	386-380
B	3.0	379-373
B-	2.7	372-366
C+	2.3	265-259
C	2.0	258-252
C-	1.7	251-249
D+	1.3	248-242
D	1.0	241-235
F	0.0	Below 234

Course Policies

Make-up examinations are only offered to students who have legitimate and/or university excused circumstances.

Note: Late work in this course is not tolerated.

Student Conduct and Discipline

North Carolina A&T State University has rules and regulations that govern student conduct and discipline meant to ensure the orderly and efficient conduct of the educational enterprise. Please consult the undergraduate http://www.ncat.edu/-acdaffrs/Bulletin 2008-2010/2008-2010_Undergraduate Bulletin.pdf

Students with Disabilities Policies

"Students with disabilities who believe that they need accommodations in this class are encouraged to contact the office of Veteran and Disability Support Services at 336-334-7765 or fax 336-334-7333 as soon as possible to better ensure that such accommodations are implemented in a timely fashion." Murphy Hall 01.

Make-up Exams

Make-up exams are given only if the student provides a university-excused absence for the exam missed.

Extra Credit

There is no extra credit work offered for this course.

Late Work

Late work is only accepted with a valid university excuse.

Special Assignments

N/A

Class Attendance

In the event that this is solely a participation course, all students are expected to attend all classes on time. Tardiness will result in penalties to be subscribed at the discretion of the instructor. If the student accumulates more than 5 unexcused absences, the student will be dropped. Three consecutive tardies will count as one absence.

Classroom Citizenship

Students are expected to attend each class on time and demonstrate respect for the class and fellow classmates. Students are asked to dress appropriately; please, no hats or caps, scarves and or headbands. Please refrain from cell phone use (texting, calling, or receiving phone call during class) as this causes other class participants to be disturbed.

Technical Support

If you experience any problems with your A&T account you may call Aggie Tech Support (formerly Help Desk) at 336-334-7195.

Field Trip Policies, Off-Campus Instruction, and Course Activities

In addition to the two required performances on campus, students are asked to see at least one stage performance off campus as well. The objective is to compare the performance they saw off campus with our performances.

Student Affairs Website: http://www.ncat.edu/~staffair/

Student Handbook: http://www.ncat.edu/~deanofst/Handbook.htm

Student Travel Procedures and Student Travel Activity Waiver: http://businessfinance.ncat.edu/ policies%20and%20procedures%20index.htm

Off-campus, out-of-state, and foreign instruction and activities are subject to state law and University policies and procedures regarding travel and risk-related activities. Information regarding these rules and regulations may be found at the website address: http://businessfinance.ncat.edu/policies%20and%20procedures%20index.htm.

Additional information is available from the office of Student Affairs, please check the website at: http://www.ncat.edu/~staffair/

Below is a description of any travel and/or risk-related activity associated with this course.

Other Policies (e.g., copyright guidelines, confidentiality, etc.)
Student Handbook: http://www.ncat.edu/~deanofst/Handbook.htm

Family Educational Rights and Privacy Act http://www.ncat.edu/~registra/ferpa_info/index.htm

Student Conduct and Discipline

North Carolina A&T State University has rules and regulations that govern student conduct and discipline meant to ensure the orderly and efficient conduct of the educational enterprise. It is the responsibility of each student to be knowledgeable about these rules and regulations. Please consult the undergraduate *http://www.ncat.edu/~acdaffrs/Bulletin_2008-2010/2008-2010_Undergraduate_ Bulletin.pdf* and graduate bulletins: 2008-2010 Graduate Catalog.doc http://www.ncat.edu/~gradsch/ cstudents.html and student handbook http://www.ncat.edu/~deanofst/Handbook.htm for detailed information about specific policies such as academic dishonesty, cell phones, change of grade, disability services, disruptive behavior, general class attendance, grade appeal, incomplete grades, make-up work, student grievance procedures, withdrawal, etc.

These descriptions and timelines are subject to change at the discretion of the Professor.

CHAPTER 1

Theatre Trivia

1. What is Broadway?

2. What is the name of the first actor in theatre?

3. What is the difference in the words Theatre and Theater?

4. In what year did theatre begin?

5. What are three types (kinds) of theatre?

6. Name four actors before 1960, two male and two female.

7. In what city or country did theatre begin?

8. Name three or more plays you have seen or know.

9. Name three present-day female actors.

10. Name three present-day male actors

11. Name two film producers.

12. Name two film or theatre designers.

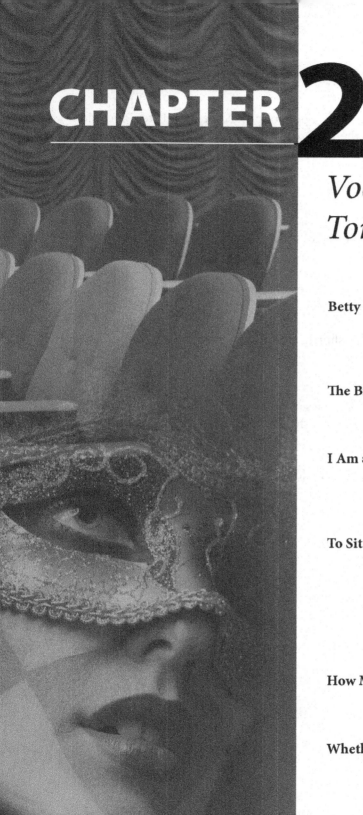

CHAPTER 2

Vocal Exercises and Tongue Twisters

Betty Brightly

> Betty Brightly bought some butter, but she said the butter is bitter, so Betty bought better butter.

The Big Black Bug

> The big black bug bit the big black bear, and the big black bear bled blood.

I Am a Sheet Slitter

> I am a sheet slitter, I slit sheets, I slit the sheet, the sheet I slit and on the slitted sheet I sit.

To Sit in Solemn Silence

> To sit in solemn silence in a dull, dark dock, in a pestilential prison with a life-long lock, awaiting the sensation of a short, sharp shock, from cheap and chippy chopper on a big, black block.
>
> ~W.S. Gilbert

How Much Wood

> How much wood could a woodchuck, chuck if a woodchuck could chuck wood?

Whether the Weather

> Whether the weather is cold or whether the weather is hot, we will be together whether you like it or not.

Peter Piper

Peter Piper picked a peck of pickled peppers, a peck of pickled peppers Peter Piper picked. If Peter Piper picked a peck of pickles, then where is the peck of pickles Peter Piper picked?

Red Leather

Red leather, yellow leather. (repeat six times)

I Thought

I thought a thought. But the thought I thought I thought wasn't the thought I thought!

Toy Boat

Toy boat, toy boat, toy boat, toy boat, toy boat, toy boat, toy boat!

Say This

Say this sharply, say this sweetly, say this shortly, say this softly. Say this sixteen times very quickly.

Silly Sally

Silly Sally swiftly shooed seven silly sheep, the seven silly sheep Silly Sally shooed shilly-shallied south; these sheep shouldn't sleep in a shack; sheep should sleep in a shed.

Sasha Sews

Sasha sews slightly slashed sheets shut, she should shun the shinning sun. A shapeless Sasha sags slowly.

Dick Kicks

Dick kicks sticky bricks! (repeat three times)

Smelly Shoes and Socks

Smelly shoes and socks shock sisters.

Unique New York

Unique New York, you know you need unique New York. (repeat three times)

CHAPTER 3

Theatre Games

CHAPTER 4

The Monologue

The Monologue is considered the actor's communication through the verbal word. What is visualized in our subtextural thoughts can be wonderful. An actor can sway the listener's thoughts if done in the most compelling fashion. It's like telling a refined story, but the most important factor involved is keeping the attention of who is listening to the monologue (spoken words). There must be consistency, be heard, understood, and most of all, believable. Plays abound in the opportunities to use images. There is what we refer to as an inner monologue (subtext), the unspoken, yet the audience is affected some way by what is said. The actor who renders a successful monologue has memorized the syntax and is able to embellish the words to make it real, believable, comical, tragic, and/or appropriate for the setting of the play or mood. Performing the monologue properly requires understanding of the text and a convincing spirit.

A. What is a Monologue?

A monologue is a dramatic speech rendered by one person, sometimes compared to a soliloquy which can be more creative in speech, yet formative and expressive.

In theatre, the monologue is the vehicle used for performative expression in the audition process.

The monologues usually showcase the performers' talent and abilities through memorization, character, diction, technique, and vocal variety. It is our measure whether an actor has the ability to do this kind of work.

CHAPTER 5

Theatre Vocabulary

Aside _____

Audition _____

Beat _____

Blocking _____

Business _____

Casting _____

Callback _____

Cheat (to Cheat) _____

Character _____

Cue _____

Downstage _____

Drama _____

Dress Rehearsal _____

Duologue _____

Dialect _____

Director _____

Emotional Memory _____

Empathy _____

Eye Contact _____

Genre _____

Improvisation _____

Inflection _____

Moment to Moment _____

Monologue _____

Actor Props _____

Prima Donna _____

Proscenium _____

Real _____

Role _____

Scoring _____

Script _____

Slate _____

Soliloquy _____

Stage Left _____

Stage Right _____

Subtext _____

Three Quarters _____

Upstage _____

Technical Acting_____

Presentational Acting_____

Representational Acting_____

The Fourth Wall _____

Emotional Acting_____

PaulRobeson Theater_____

Richard B. Harrison Auditorium_____

CHAPTER 6

Viewing a Live Performance

During the semester, students are asked to see three live performances — two on campus and one production off campus. A live performance is one that has live persons on stage rendering the action and speaking lines from a scripted play. Movies or films cannot be considered a live performance as the actors are not virtually living and breathing the scripted text. In some cases, when we do not have the live production option, the instructor will substitute this option. When viewing a play, secure the program and watch the play closely; take notes if need be. However, the main reason for watching the live performance is to see the differences in a live production and a movie or film. Questions to ponder are as follows:

1. Did you understand the actors on stage (could they be heard)?
2. Was their diction clear?
3. Were their characterizations believable and suited for the play's theme?
4. Did you empathize or have sympathy for any of the characters?
5. Was the play's spectacle real or did it evoke a special mood? (Sets, costumes, lighting, makeup, etc.)
6. As an audience member, were you moved in any way?
7. Who or whom were your favorite actors?
8. What were the language and/or regional dialect?
9. Would you recommend the performance to others?
10. Was your experience your first or have you attended a live performance before?

A. Writing a Critique for a Live Performance

Writing a critique for a live performance can be a lively activity; first of all, I would encourage you to think of yourself as a theatre critic. See the production as if you were a kid — that is, do not have expectations — attend with an open mind and a "go with the flow attitude." This way your mind is clear and open and able to really enjoy the performance. Do not consider seeing the performance as a chore or assignment. Let your mind react to the characters' action and flow of the play. Go with an empty cup and let your cup be filled with what the production has to offer. Post seeing the production, have a conversation with someone who attended the production with you, even if it is someone you do not know. Write any notes that will assist you in writing a critique about what you saw. When critiquing the production, here is a list of components to be aware of after you have fully consumed the production:

 a. Who or whom were your favorite actors?
 b. What were the production themes?
 c. Did you like or was the show's spectacle appropriate?
 d. Were you affected in any way post viewing?
 e. Did you learn something about the production that you did not know before?
 f. Would you recommend the production to others?
 g. What was your over-all experience like?

After gathering the above information, write a one-page critique while the production is fresh on your mind, turn it in to the instructor no later than one week post viewing.

B. What Makes a "Live Performance?"

A live performance is one that is on an open stage with real, live actors rendering a story to an audience. The reason this is considered Live is because there is live verbal speech, and persons or characters that an audience can smell and touch physically, hear and see closely. A film, movie, taping, or video is not live and is not acceptable as a "Live Performance." A Live Performance is only considered just that when an audience and the characters on stage share real, live intentions, subtext, and purpose.

CHAPTER 7

The Duologue

The Duologue is the act of two people performing a scene from a play. The great thing about a duologue is two actors are sharing the story, as you have probably heard before, "two heads are better than one." The dynamics two people can give to a scene are endless. The energy they both permeate is usually spell-binding if performed correctly. Similar to a monologue, the same rules apply — the duologue must engage the listener (audience) by telling a story, move them to believe in the work presented, and leave them with wanting more. It is imperative that the audience is left with complete understanding and entertained by what was said. The duologue encourages partner work and enables the actors involved to be dependent upon each, unlike the monologue where the actor is forced to work solo.

A. What Is a Duologue?

A Duologue is a scene requiring two actors to work together to tell the story and produce the scene. The two actors have set dialogue and each have an investment to play the scene to the best of their ability.

B. Working with a Partner

Working with a partner can be fun, but can also be difficult, in that decisions made in the scene are made by two people, and require the participants to share and understand that they must show and appear to be united in the presentation. They must bring equal footing to the final presentation and they must get to know each other well.

CHAPTER 8

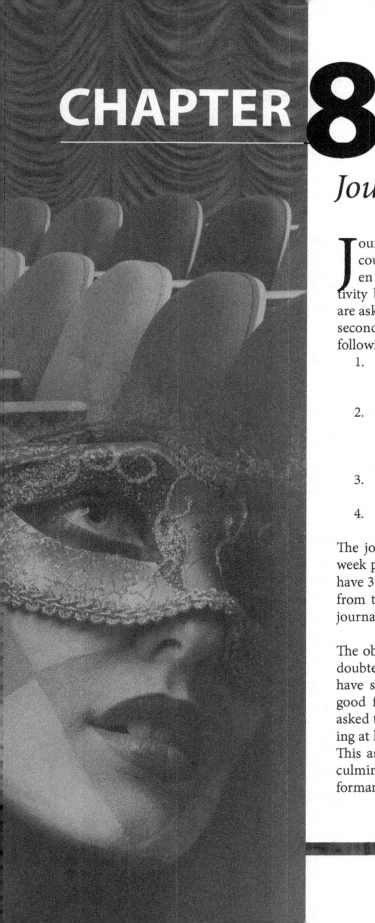

Journal Writing

Journal writing is a part of the success in this course. In years past, journal writing has proven to be a great way to capture day-to-day activity beyond the classroom experience. Students are asked to journal four times a week, starting the second week of class. Journal specifics include the following;

1. Please **date** your entry and if you are able, account for the **time of day** the entry was recorded.
2. You may talk about anything that is on your mind: people, relationships, places, things you want, expectations, needs, desires, observations, etc.
3. The entry should be a short paragraph to half a page (**no one-word entries please**).
4. Please record any details you wish.

The journal process is to take place in an eight-week period; at the end of that period, you should have 32 entries. There will be journal check-points from the instructor only to see if each student is journaling.

The objective of this assignment is as follows, undoubtedly what I have found is that journal entries have some connective resources. This makes for good final monologue material and students are asked to construct a **Final Monologue** by combining at least three of the entries they have recorded. This assignment has proven to be a great way to culminate the course and reveal a great final performance, because the material is about them.

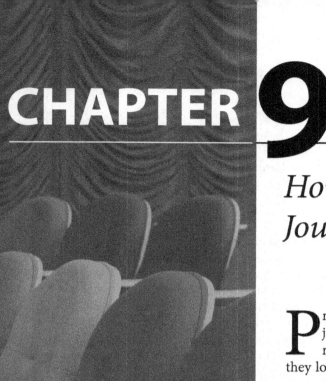

CHAPTER 9

How to Write a Journal Monologue

Preparing the actual monologue from your journal entries is quite easy. Students should reflect and re-visit all of their entries; and as they look back and reflect on the entries that have some attachment to one another, narrow down the entries that had issues and themes that were similar. For example, an entry you wrote in the beginning might be similar to something you wrote in the middle or toward the end of the semester. In some cases your entry may be a continuation of an entry you did not complete the first time. The final monologue should combine at least three of your entries to develop enough scripted words to make up the final monologue. The monologue is then scored and edited befitting of public presentational form. A copy must be given to the instructor as part of the final grade.

Student Journal Monologues

My Mother
by Tyree D. Hearn

My Mother, she was a lovable and faithful Christian woman who loves God very much just like my grandmother (which is her mother). She always smiling and feels the room with full of joy and let us know that everything will be alright. I remember when I was growing up; most of the time if we get in trouble, my mother will tell my father about it and we already know that we were going to get a whooping. Anyway, my mother touched a lot of people in her life and was loved by many. March 20, 2015, I got a phone call from my dad telling me to come home and see my mother; I know it was getting close to her time. When I saw my mother lying in the bed, she was in pain but when she saw me she was smiling and she said "my baby boy." Anything you can think of I've done; prayed, cried, grieve because I did not want my mother to go. I was holding her hand and ask her "Do God make Mistake?" and she turns her head side to side and said, "No God doesn't make mistake." Out of this whole situation, my family and I were being selfish and trying to keep my mother here, suffering and in pain but sometime we just had to let go and let God. March 22, 2015, the day the lord called my mother home, I broke down and cried and prayed for comfort and peace during this time of grieving. When folks find out about my mother's passing the most common people say to me is "I am sorry for your loss." I appreciate the condolence but as I was thinking "loss?" Let me tell you about the definition of the word "loss." When you "loss" something or someone it means that you are no longer in possession, or control of someone or something. Pretty much you will never find it or them again. I did not lose my mother; I know where my mother is, I know where she at. She is in her heavenly home, happy, waiting on us to come join her. For those who is a believer yall know what I am talking about. For the word said "Do not let your hearts be troubled. For those who believe in God; also believe in me. My Father's house has many rooms; if that were not so, would I have told you that I am going there to prepare a place for you? And if I go and prepare a place for you, I will come back and take you to be with me that you also may be where I am. You know the way to the place where I am going. I'm just letting everybody know; this is earth is not my home, I'm just passing by. I am here on this earth to do what the lord have for me and when my job here is done, I too will be with my heavenly father and will be with my mother once again. So for those who loved one is still here, called them and let them know you loved them and appreciate everything they have done for you. I know I appreciate everything my mothers have done for me; my parent raises my sibling and I to become responsible adult who love God as much as my mother did and I will honor her for the rest of my life. I encourage you all to honor your love one while they here on this earth because you'll never know when it will be their last time here before the lord called them home.

Title to Come
by Victoria Ervin

There's who we are and there's who we pretend to be. Throughout life the two blend with one another into the person we are meant to become.

What other people think about you is not important, it's who you are and what you think about yourself that matters the most.

Life is all about choices the ones you make and the one's you don't

There is a reason and a purpose for everything that happens in life.

If you don't like something then change it. You are in control of your own life. This is why I live life with no regrets. Hoping I'm not making mistakes.

Never lose yourself trying to be something else, for someone else, be true to you.

Perfection is over-rated not one person is truly perfect. However it is each one of our imperfections that makes us unique and interesting.

There are times when I wish I could stop time and live in a moment as long as I wish. Living in the moment instead of anticipating the future.

Time changes many things in life.

But dose time change people, or do people just change over time? It is only natural for people to change and grow becoming a grater or in some cases lesser version of who they used to be.

What matters most in life? Who matters most in life?

Some people may mean the world to you now; however the same person may find themselves forgotten in a box of your old memories. Someone who was once so close, knew all your deepest thoughts that you share with only God and yourself. They were once apart or your everything and now they are nothing just a fading memory.

Them Bittersweet Days
by Anthony Fannoh III

Them Bittersweet days, bitter...

Woke up this morning with an email saying that my classes will be dropped if I don't pay a balance of 1,800$. Right away my mood changed, all I'm thinking is that there's no room for setbacks with this school thing, I need out ASAP!

Talking to dad....

Hey dad, I'm not doing. I just got the worst email, I know money is tight right now, I have to pay this amount is 4 days or else I have to drop classes and then that means I can't graduate until 2016, omg!

Dad: hang in there we will figure it out

On the phone with financial aid

Sir have you tried to get some loans, here are the loans that our school work with

Me: I'm not getting approved for any of these loans, my dad won't get approved, neither will my mom or anyone else I know. My last option is to pay 600$ to start the payment plan, I hope pops has that money.

Phone with dad: all you have to pay is 600$, then give me the number I will take care of it.

Me: I was happy AF! All I was thinking to myself was like damn man, I told so many people I'm gonna be done in December, I'm drained from school too!

A few days later:

A few days later, it was a Wednesday, a couple hours before my 3:00 acting class. My mom tells me to get my brother and sister on the phone she wanna talk to us all. We all play phone tag for 30min, we finally got everyone on the phone. All this just to hear that her cancer was back and it was in attack and serious.... Sweet day gone sad...

Darkie
by Taylor Blow-Williams

When I was a little girl, I would always ask my Grandmother why she was white and I was black. You see, my Grandmother had that high yellow skin – so light that she could have passed for white if she wanted to. And if that wasn't enough, she had those long, silky-black tresses that fell over her shoulders almost perfectly. In my six year-old eyes, she was the most beautiful woman on earth. And as a child, I was infatuated with her light skin and long hair- well, I really didn't have to daydream about long hair. My high ponytails hung down to the middle of my back. So I was okay in that department, but to me, light skin was everything. Hell, my Mama was light, my grandmother was light, my auntie, cousins, and both my brothers were light as well. My Dad and I were the only "darkies" in the family and I hated it. I hated my skin so much that once, I even tried to scrub the skin off of my lips because I thought they were dirty – I didn't have the pink lips that my Mama and Grandmother had. My lips were brown and I just thought they were dirty. It didn't take long before my family figured out how much I resented my skin tone. I was always talking about how dark I was. Hell, I was afraid to even step outside because I didn't want to get a tan. I hated it when my cousins would call me chocolate or tell me that I had gotten a tan. I even resented my other Grandma for being my complexion, even though she would always try to make me feel better about my color, telling me that I was pretty pecan brown like her and that I was still beautiful. It never mattered though, because she'd always ended up telling my brothers that they had that cinnamon skin like our mama. That used to make me so mad but I'm glad that I grew out of my infatuation with light skin. It took me a while, but eventually, I grew into loving myself *and* my skin. And when I have daughters, no matter what shade of brown they turn out to be, I'm going to make sure they know, from birth, how beautiful they are.

Title to Come
by Sheila C. Washington

The average marriage is an economic arrangement. Nothing more, nothing less. If a woman had been able to come to the table in 1914 and negotiate in earnest with her betrothed, she could let him know that the depth of her affections would probably be dependent on how well he was able to keep her. He should in turn take much consideration on whether her resume needed to reflect more than, "Fair of face; speaks well when spoken to, and can play the harpsichord and sing a lovely tune after dinner." She could let him know that she had been bred and reared from birth for the ultimate goal of marriage; therefore, he shouldn't expect her to squander her livelihood on him if he wasn't willing or able to produce a comfortable living for her. He then could let her know that he would take total control of her life, ownership actually, and all that she owned; she should expect to have him come into her bed at will and ravage her body, no matter how vile she found the act; and there was an expectation she had working parts that could reproduce healthy children, most specifically, males. She would tell him that for every healthy child born she would expect a sable, and that she was only learning to cook different meals because she wanted a bigger house. The fact that she actually enjoyed the physical act does not change a thing. She knows she has the more valuable commodity. The marriage vows would not mention love, for love would not be a factor. This is a barter situation, a trade for goods and services. He brings his stuff to the table, she brings her stuff to the table, and all is well.

When I hear the term "gold digger" I am somewhat confused. How is it that in a society where a woman has been trained from infancy to prepare to marry well; and it has been said that it is necessary for her to use her powers of manipulation to win a man's affections; is now maligned with a derogatory term for perfecting what men and society trained women to do? According to Emma, marriage and love have nothing in common. One hundred years later, women have learned to ask the question Tina Turner put so eloquently, "What's love got to do with it?"

Title to Come
by Dorian Davis

Shut up! 9 years.. 9 years and I haven't heard from you.. Not a word.. Not even a peep. For years I waited for you.. I reached out to you trying to find you.. Trying to hear something, but you were never there.

Well........ at least I thought you weren't. I thought you were gone.. Maybe you were off in another state, maybe you had remarried into a new family, maybe you didn't care about your only son.. You were as good as dead to me. And even when I had given up hope, something told me that you were still out there. Still put there watching.. waiting.

And you were.

You were always there like the puppeteer that you are, pulling strings. Putting the whole family against each other. Putting me against my own mother.. The woman who brought me here onto this very earth. You are darkness.. You are not good. Nothing you've ever done has lead to good.

No shut up! I remember those letters. Those letters that you swore were from you ... But that was Uncle Derrick in your place. Playing the father role because you never could. You could never love me like a father should, you could never support a family like a father should. You throw your checks my way like I'm some charity case that needs your support.. Hell no! But you still had the audacity to watch over me as if you're some guardian angel. You ain't shit!

But I'll let you know this.. I am twice the man you ever were. Twice the man that you ever hoped to be. I will not lie like you did.. I will not deceive .. I will not coerce my family into hating the only one that truly loved me. I am light.. And I refuse to dwell in the dark like you.

Title to Come
by Ra-Anne Davis

Look I got to tell yall a story but you have to promise not to mention this to my brothers and sister. If they knew about this it would end me. When we were younger, my brothers and sister loved to play outside. I loved homework and reading. Our after school activities were not the same, as you can see. I hated the outdoors. I was afraid of dogs, cats, birds, and any type of insect you could find. Even the ones you didn't find.... I knew they were out there. One day, my mother came home from work irritated. As always, she decided to take out her frustrations on me. this time it was not physically harming to me. So I did it with no hesitation. She wanted me out of the house for a few hours. So, she said "go outside and play with your brothers and sister." Surprised, I went. Five minutes after sitting on the porch watching them, I tried to go back in the house. my allergies began to flareup and I had to pee. I swung open the screen door, so close to safety. I turned the knob on the front door quickly. It was locked. It was locked!!!!! Paranoia washed over me. I began thinking of all the things that could go wrong with me being out side. I was terrified. I banged on the door but she never came to let me in. I pleaded loudly at the door. Still nothing. After at least ten minutes of useless crying, I accepted my fate. I went down the stairs and walked to where my siblings played. They were making mud pies. My sister said since it had rained the day before the mud was perfect. They had our dog container filled with water and they were using that as water for the pies. I was disgusted. They were making the mud pies with their hands. There was mud all over them. All under their nails. All over their clothes and shoes. Eww. One of my brothers named Keshawn loooooves bugs. He picked up something slimy and tried to put it on me. I immediately called for help and ran. Laughing, they chased me to the backyard. This time, each one of them had one of those slimy bugs. he said don't be scared it's only a worm. Only a worm?!!! They look like monsters. No face. Arms. Legs. Nothing appealing. This was the moment I knew I hated worms. 12 years later I'm in college. I hate the spring for two things and two things only: allergies and worms. Whenever it rains I have to make sure I watch my surroundings. I don't want to step on any worms. I don't even want to see any worms close to me. So every time it rains, I'm doomed to looking down. Watching my steps to make sure I don't cross paths with worms. I'm terrified of them. Did you know if you cut worms into pieces they will all become a new worm? The only way to kill it is to smash it into the ground. They are the scariest bug I've ever seen. I'm sure my brothers and sister thought I would get over this "silly" fear. But I haven't. so please, don't mention it to them.

CHAPTER 10

Class Forms

A. Stage Diagrams

B. Monologue Evaluation Form

C. Duologue Evaluation Form

Stage Diagram

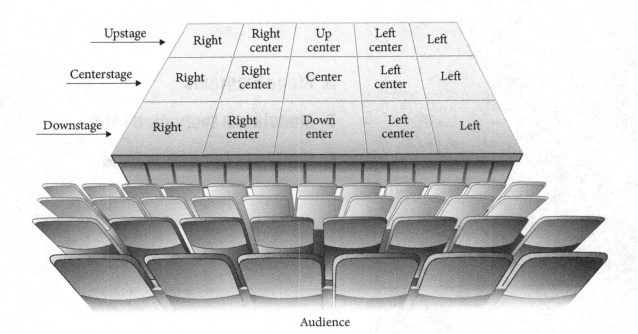

Upstage →	Right	Right center	Up center	Left center	Left
Centerstage →	Right	Right center	Center	Left center	Left
Downstage →	Right	Right center	Down enter	Left center	Left

Audience

Stage Diagram

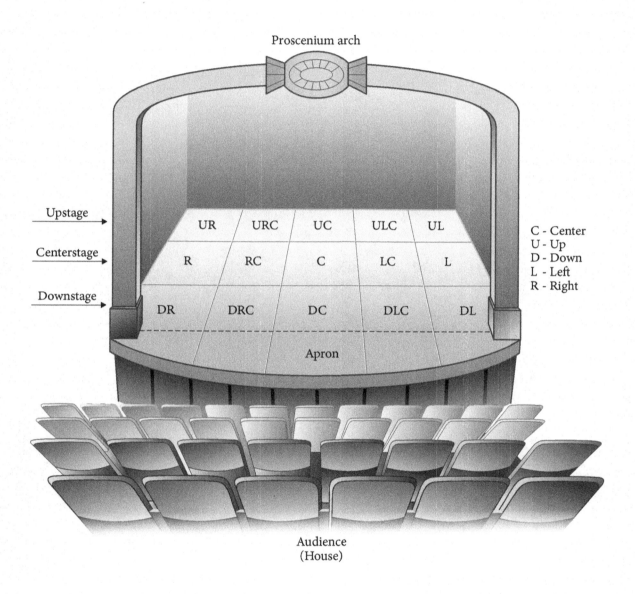

Proscenium arch

Upstage

Centerstage

Downstage

UR	URC	UC	ULC	UL
R	RC	C	LC	L
DR	DRC	DC	DLC	DL

Apron

C - Center
U - Up
D - Down
L - Left
R - Right

Audience
(House)

DEPARTMENT OF VISUAL AND PERFORMING ARTS
THEATRE ARTS
THEA 110
Final Monologue

NAME_____DATE_____

CHARACTER_____

PLAY_____

MONOLOGUE EVALUATION FORM

Intellectualization (1-5)		
Movement (1-5)		
Diction (1-10)		
Characterization (1-10)		
Techniques (1-5)		
Memorization (1-5)		
Vocal Variety (1-5)		
Reservations (1-5)		

TOTAL [] GRADE []

Mr. Gregory Horton
Associate Professor

COMMENTS:

DEPARTMENT OF VISUAL AND PERFORMING ARTS
THEATRE ARTS
THEA 110
Final Monologue

NAME_____DATE_____

CHARACTER_____

PLAY_____

MONOLOGUE EVALUATION FORM

Intellectualization (1-5)		
Movement (1-5)		
Diction (1-10)		
Characterization (1-10)		
Techniques (1-5)		
Memorization (1-5)		
Vocal Variety (1-5)		
Reservations (1-5)		

TOTAL [　　　　　] GRADE [　　　　]

Mr. Gregory Horton
Associate Professor

COMMENTS:

DEPARTMENT OF VISUAL AND PERFORMING ARTS
THEATRE ARTS
THEA 110
Final Monologue

NAME_____DATE_____

CHARACTER_____

PLAY_____

MONOLOGUE EVALUATION FORM

Intellectualization (1-5)		
Movement (1-5)		
Diction (1-10)		
Characterization (1-10)		
Techniques (1-5)		
Memorization (1-5)		
Vocal Variety (1-5)		
Reservations (1-5)		

TOTAL [] GRADE []

Mr. Gregory Horton
Associate Professor

COMMENTS:

DEPARTMENT OF VISUAL AND PERFORMING ARTS
THEATRE ARTS
THEA 110
Final Monologue

NAME_____DATE_____

CHARACTER_____

PLAY_____

MONOLOGUE EVALUATION FORM

Intellectualization (1-5)		
Movement (1-5)		
Diction (1-10)		
Characterization (1-10)		
Techniques (1-5)		
Memorization (1-5)		
Vocal Variety (1-5)		
Reservations (1-5)		

TOTAL ⬜ GRADE ⬜

Mr. Gregory Horton
Associate Professor

COMMENTS:

DEPARTMENT OF VISUAL AND PERFORMING ARTS
THEATRE ARTS
THEA 110
Final Monologue

NAME_____DATE_____

CHARACTER_____

PLAY_____

MONOLOGUE EVALUATION FORM

Intellectualization (1-5)		
Movement (1-5)		
Diction (1-10)		
Characterization (1-10)		
Techniques (1-5)		
Memorization (1-5)		
Vocal Variety (1-5)		
Reservations (1-5)		

TOTAL [] GRADE []

Mr. Gregory Horton
Associate Professor

COMMENTS:

DEPARTMENT OF VISUAL AND PERFORMING ARTS
THEATRE ARTS
THEA 110
Final Monologue

NAME_____DATE_____

CHARACTER_____

PLAY_____

MONOLOGUE EVALUATION FORM

Intellectualization (1-5)		
Movement (1-5)		
Diction (1-10)		
Characterization (1-10)		
Techniques (1-5)		
Memorization (1-5)		
Vocal Variety (1-5)		
Reservations (1-5)		

TOTAL [] GRADE []

Mr. Gregory Horton
Associate Professor

COMMENTS:

DEPARTMENT OF VISUAL AND PERFORMING ARTS
THEATRE ARTS
THEA 110

NAME_____DATE_____

CHARACTER_____

PLAY_____

DUOLOGUE EVALUATION FORM

Intellectualization (1-5)		
Movement (1-5)		
Diction (1-10)		
Characterization (1-10)		
Techniques (1-5)		
Memorization (1-5)		
Vocal Variety (1-5)		
Reservations (1-5)		

TOTAL [] GRADE []

Mr. Gregory Horton
Associate Professor

COMMENTS:

DEPARTMENT OF VISUAL AND PERFORMING ARTS
THEATRE ARTS
THEA 110

NAME_____DATE_____

CHARACTER_____

PLAY_____

DUOLOGUE EVALUATION FORM

Intellectualization (1-5)		
Movement (1-5)		
Diction (1-10)		
Characterization (1-10)		
Techniques (1-5)		
Memorization (1-5)		
Vocal Variety (1-5)		
Reservations (1-5)		

TOTAL [] GRADE []

Mr. Gregory Horton
Associate Professor

COMMENTS:

DEPARTMENT OF VISUAL AND PERFORMING ARTS
THEATRE ARTS
THEA 110

NAME_____DATE_____

CHARACTER_____

PLAY_____

DUOLOGUE EVALUATION FORM

Intellectualization (1-5)		
Movement (1-5)		
Diction (1-10)		
Characterization (1-10)		
Techniques (1-5)		
Memorization (1-5)		
Vocal Variety (1-5)		
Reservations (1-5)		

TOTAL [] GRADE []

Mr. Gregory Horton
Associate Professor

COMMENTS:

DEPARTMENT OF VISUAL AND PERFORMING ARTS
THEATRE ARTS
THEA 110

NAME_____DATE_____

CHARACTER_____

PLAY_____

DUOLOGUE EVALUATION FORM

Intellectualization (1-5)		
Movement (1-5)		
Diction (1-10)		
Characterization (1-10)		
Techniques (1-5)		
Memorization (1-5)		
Vocal Variety (1-5)		
Reservations (1-5)		

TOTAL [] GRADE []

Mr. Gregory Horton
Associate Professor

COMMENTS:

GLOSSARY

Acting– One pretending, replicating, and/or mimicking someone else for pleasure or for pay.

Actor– The unisex term for that individual who mimics someone else on stage and in film.

Aside– When an actor removes their character and speaks to an audience directly.

Apron– The curved addition added to a stage to bring the action closer to the audience.

Applause– Giving positive influence from clapping your hands.

Audience– Persons who watch a performance that sometime render feedback, through a discussion or applause.

Audition– An actor showing their skills and talents to a director, judge, or casting agent.

Beat– A paused moment in the play or script, sometimes a breathing moment.

Black box– An intimate place for performing, usually seating under 100 and sometimes painted black.

Backstage– Any area beyond the stage and behind the scenes not seen or available to the audience.

Back wall– The very back, hard structural surface at the back of the stage.

Blocking– The actors' movement on the stage, referring them to location and placement.

Broadway– A street in Manhattan, NY where all of the major theaters are housed.

Cast– A group of actors chosen by the director to be in a production.

Character– The role that the actor portrays on stage.

Center stage– Standing in the central portion of the stage, also known as "the hot spot."

Cheat– Refers to the actor opening up on stage so the audience can see their expressions and full body.

Costume– Any clothing worn by actors on the stage.

Comedy– Theatre that encourages or makes one laugh.

Cue– The line or entry point of an actor into a scene.

Director– The artistic person in charge of the production, who sets the conceptual framework of the production.

Designer– One who creates the spectacle for the stage through lighting, scenery, costumes, sound, and makeup.

Design team– A team of designers, technicians, theatre management, stage management, and director, who meet and create the production's design elements.

Drama– A play with serious imagery and tone. Sometimes one will say a person is giving drama; this means they are over-dramatic in their actions.

Dramaturge– One who is the theatre historian for the play.

Dress rehearsal– The final rehearsal before the opening night of the play.

Dressing room– The space where actors put their costumes on their bodies.

Downstage– The act of moving toward the audience.

Duologue– Two people acting in a scene together.

Electrics– A bar on which lighting instruments hang, above and in front of the stage.

Emotional acting– The ability to evoke the memory of feelings that best fits how the character needs to feel on stage.

Entrance– The act of coming onto the stage or scene.

Eye contact– Actors catching the steady eye of a scene partner to evoke mutual understanding.

Exit– The act of leaving a scene or the stage.

Farce– Comedy exaggerated beyond the norm; extremely funny circumstances.

Fitting– The act of trying on costumes to be sure they fit the actor properly.

Forth wall– The imaginary wall that separates the actors and the audience.

Full back– When the actor is turned upstage away from the audience.

Genre– A type or kind of theatre.

Green room– The room in which the actor retires to rest and rejuvenate, the gathering room for the actors.

House– The part of the theatre where the audience is seated, just before the apron and stage.

Improvisation– Acting off the cuff; spontaneous acting with no formal script.

Mimic– To copy someone or something exactly.

Melodrama– A serious play in which the primary emphasis is on spectacle and is usually driven by music undertow.

Monologue– A long speech by one character without any interspersed dialogue by other characters.

Mood– The dominant atmosphere created by the various elements of a production.

Musical– A play driven mostly by music, with some dialogue.

On stage– The act of being on the main floor of the stage.

Opening night– The opening or first performance of the play.

Play script– The written word document written by a playwright that the actors and design team follow.

Playwright– The author and writer of the script.

Prima donna– An actor who is accused of over-acting and is overly confident, so much so that they don't care about anyone but themselves.

Producer– The financial backer for a production.

Profile– When the actor is facing left or right so the audience sees their side.

Proscenium– The wall and arch that set off the stage area from the audience.

Soliloquy– A monologue spoken by the actor as an extension of his or her thoughts not directed to or by convention.

Spectacle– The visual elements on the stage dealing with the lighting, costumes, scenic and sound design.